HENNA
PAINTING

Sabine Kühne

AURUM PRESS

First published in Great Britain
2000 by Aurum Press Ltd
25 Bedford Avenue, London WC1B 3AT

Copyright © vgs verlagsgesellschaft, Köln 1998

FIRST ENGLISH-LANGUAGE EDITION

First published by vgs verlagsgesellschaft, Cologne

A catalogue record for this book is available from the British Library.

ISBN 1 85410 689 9

10 9 8 7 6 5 4 3 2 1
2004 2003 2002 2001 2000

Design by Don Macpherson
Printed in Singapore by C.S. Graphics

CONTENTS

HENNA PAINTING: AN INTRODUCTION

The Western world seems to have become obsessed with Eastern culture. Many people believe Western culture has become too cold, too stark, too impersonal; they long for more feeling and spirituality in the world around them and wish for the contentment and balance often associated with Eastern religions and philosophies. They look to the East for quality of life, peace and sincerity.

This passion for the East is particularly apparent in the fashion industry, where the meeting of Eastern and Western ideas is expressed in a combination of traditional philosophies with the flamboyance of fashion. Body art is now *the* fashionable accessory. Henna painting lends men and women the sensuality of the Orient and the mystical eroticism of the unique artwork.

It is not known exactly when people began to experiment with colour and to paint or decorate their bodies. However, on all continents of the world, humans have surrendered themselves to the magic of colour and a desire to enhance their own appearance. Indian, Moorish and Celtic patterns as well as Greek antiquities have inspired me to create the intricate henna designs given in this book.

Make-up is connected to seduction, self esteem and the visualisation of inner feelings. Colours, hairstyles, masks and hair accessories all serve as ways to transform the face or body imaginatively and to express one's own idea of beauty.

See and be seen. Be different. Be unique.

Sabine Kühne

ORIGINAL HENNA DESIGNS

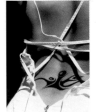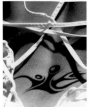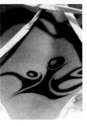

An imaginative design in this usually unexposed position is both stylish and eye-catching. The combination of traditional and modern ornamentation is particularly effective.

This design was applied freehand using tattoo ink and a paintbrush.

This unusual accessory enhances the design of the dress and is appropriate for a special day or evening occasion.

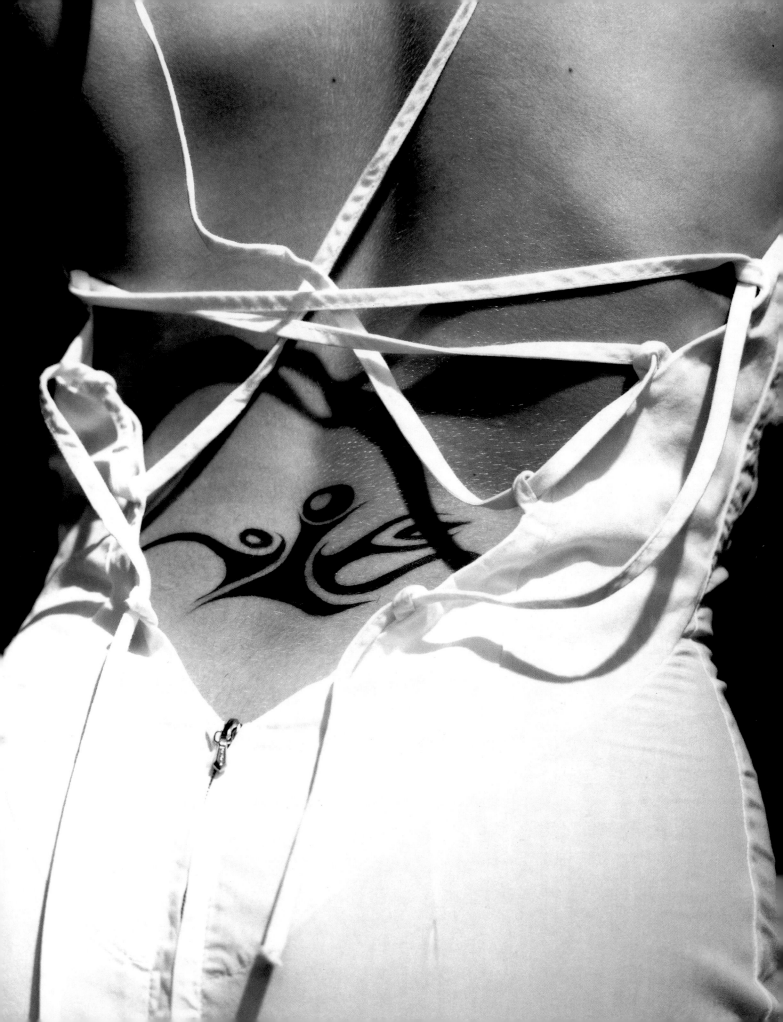

Henna tattoos for fashion-conscious men! This design is influenced by Celtic patterns, which are currently very fashionable; they can be recognized by the interweaving or interconnecting lines. This kind of design looks most effective on its own.

As these lines must be very accurate and, above all, symmetrical, it is best to use a stencil or make one of your own (see page 80). If you would like to use our exact design, copy it from this page.

The tattoo will be paler in colour if you use henna. If you want to achieve a shade as dark as ours, work with a tattoo pencil or tattoo ink.

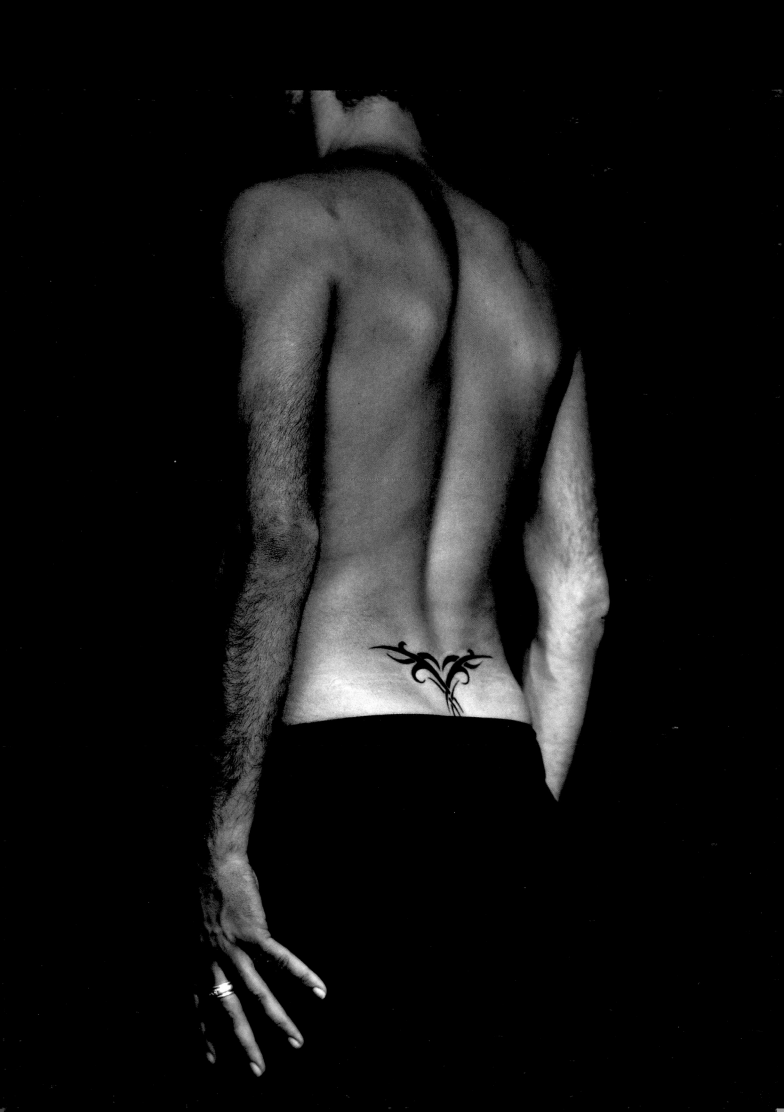

Less can be more: a minimalistic design around the belly button doesn't take long to create and it can have great impact. Round, open shapes work well here, such as this sun motif.

A pattern around the belly button can look stunning, and since it is so discreet, it is easy to maintain for a long period. If you only want to wear the design for one particular occasion, you can draw it more quickly with an eyeliner pen or tattoo pencil. It is best to draw this motif freehand so that you can adapt it to the exact shape of your belly button.

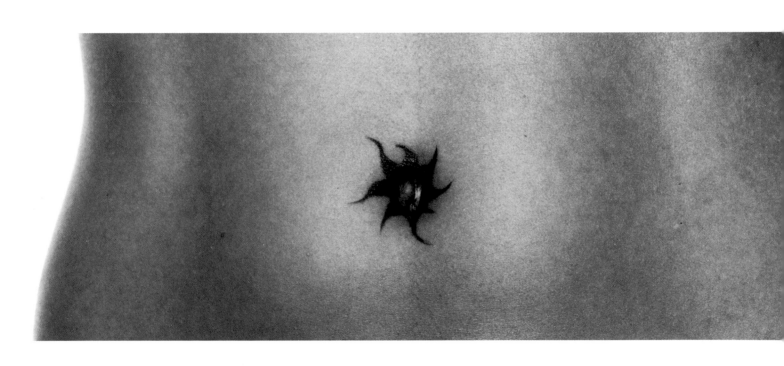

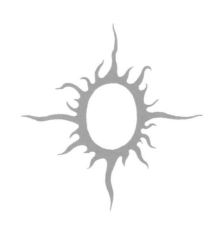

15

If you want something rather more conspicuous, you can broaden the sun motif into an intricate band. Curves, dots and round shapes all look good. This kind of band should be relatively delicate.

Whether you are on the beach, in the swimming pool, or just wearing a short top, a design on your stomach looks particularly impressive.

Paint the design using henna if you would like it to last for a long time. For something less permanent, or if you want to work with different colours, use a fine brush and paint with tattoo ink.

Typical Celtic patterns provide excellent inspiration for a band of this kind. One such example is shown above.

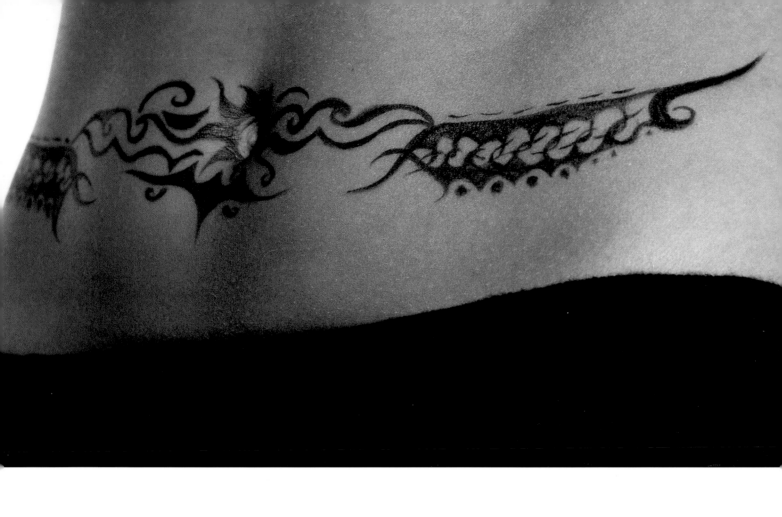

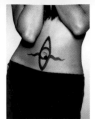

Bold, modern ornamentation suits our current trend of bare stomachs – you just need to be brave! This style of painting works best with simple clothes so that there is nothing to detract the attention away from the design. For best results, this highly individual design should be applied with an eyeliner pen or tattoo pencil.

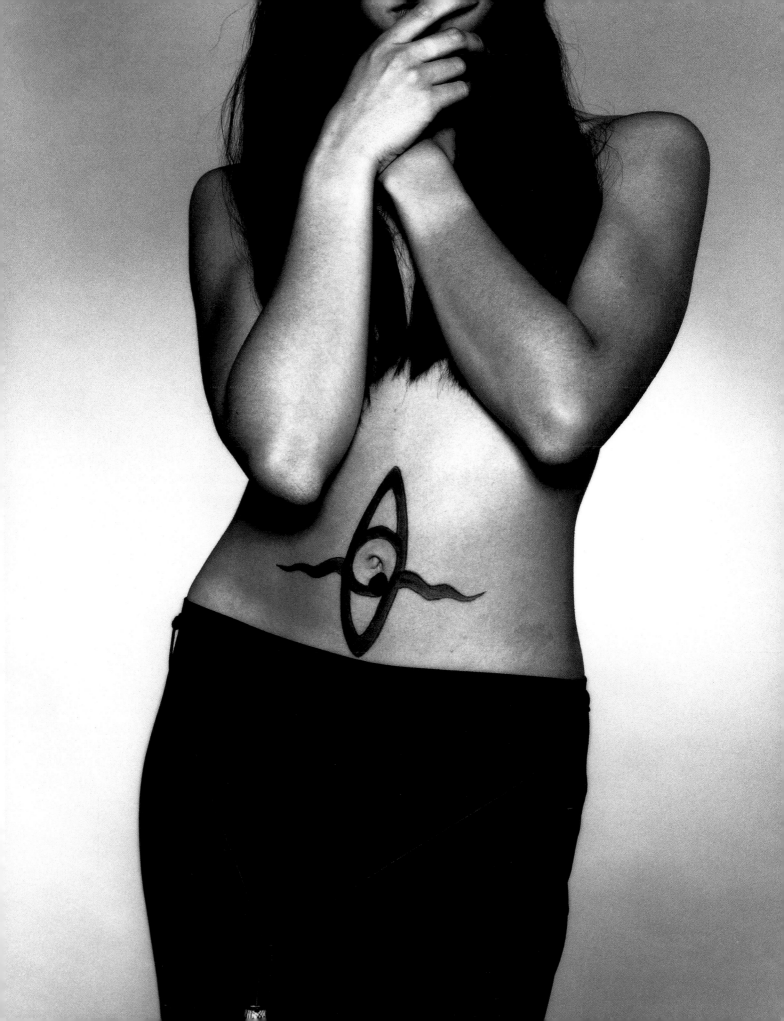

The inspiration for this extravagant design came from an Italian fashion catalogue. A man certainly needs to be fairly courageous to wear this, but it isn't permanent and could offer a stylish alternative to the traditional tie. As this pattern has to be 100 per cent symmetrical – otherwise it looks terrible – you should prepare a stencil and transfer the lines on to the skin first (see page 80).

This design was painted with face paints, for which you can find full step-by-step instructions on pages 85–6. Use your imagination in selecting the right colour for you. We used an orange colour similar to henna (raw sienna).

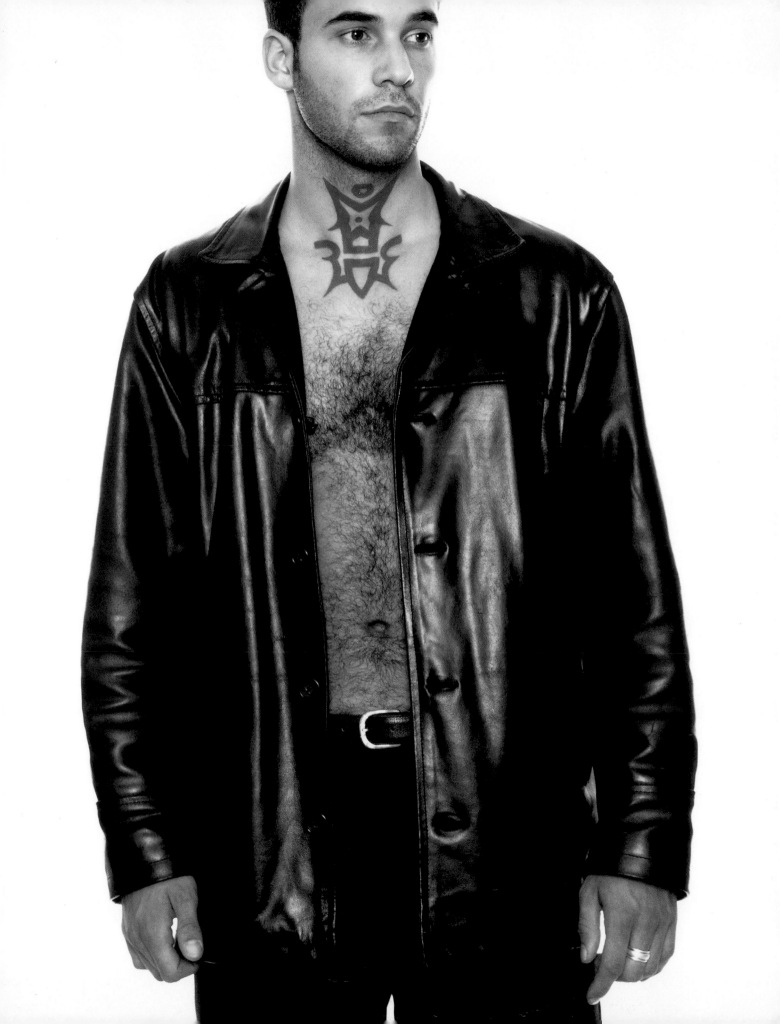

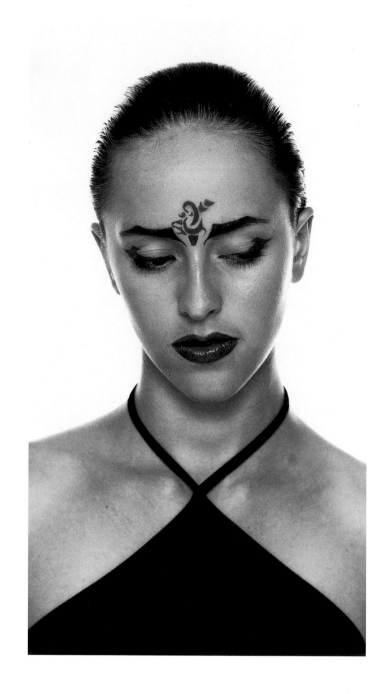

A truly exceptional look. You can conjure up extremely individual eye make-up using eyeliner pens or tattoo pencils.

22

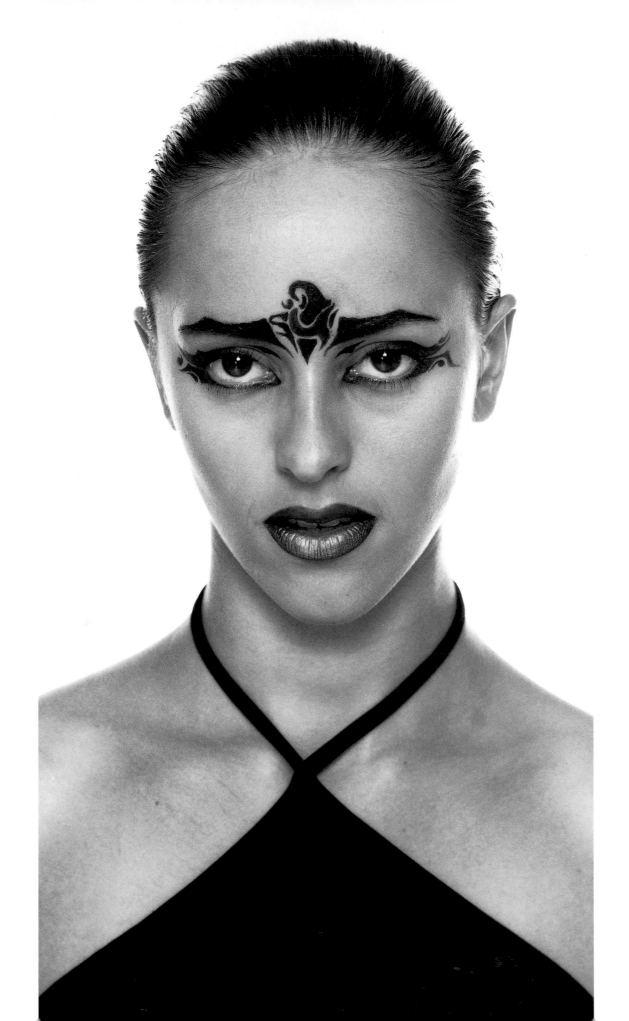

A relatively simple but very effective design, with great impact. If you paint this sun motif with henna, the outcome will of course be much paler. Use a tattoo pencil to create this kind of dark outline.

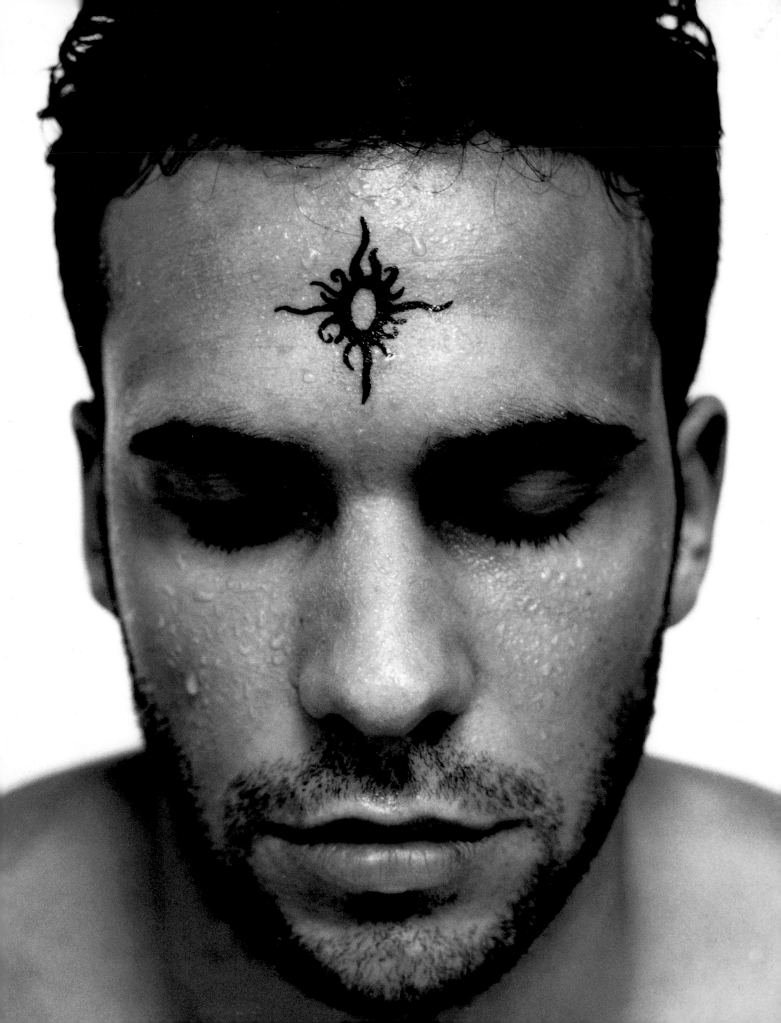

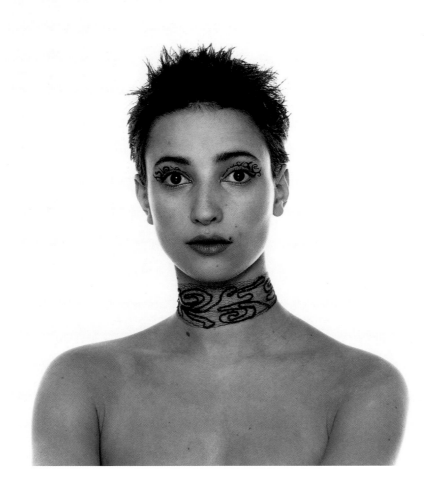

A classical pattern on delicate net wrapped around the neck was the inspiration for this matching eye make-up. Face paints were applied with a thin brush and fixed with translucent face powder.

The pattern could also be continued underneath the eyes.

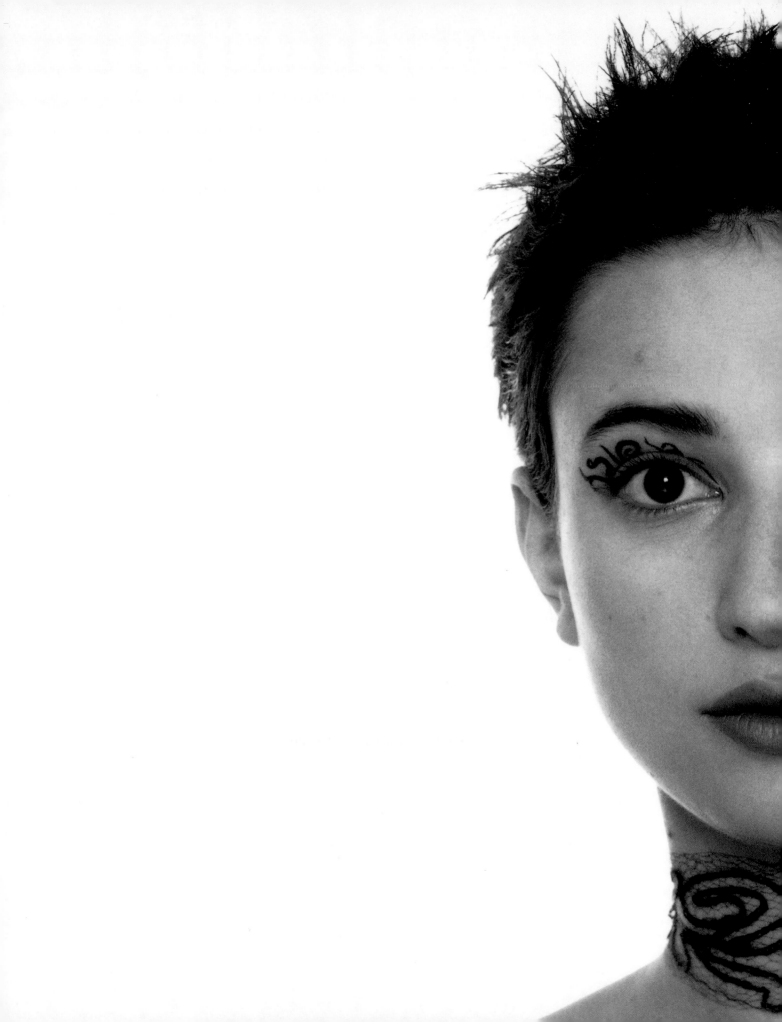

Intertwining Celtic patterns make unusual eye make-up.

These fine lines are best drawn with face paints or an eyeliner pen. As this look is very bold, it works better when worn with simple clothes. Be sure to consider which colours best suit your eyes.

A beautiful example of a Celtic design is given here. This could also be used for a band around the arm or leg.

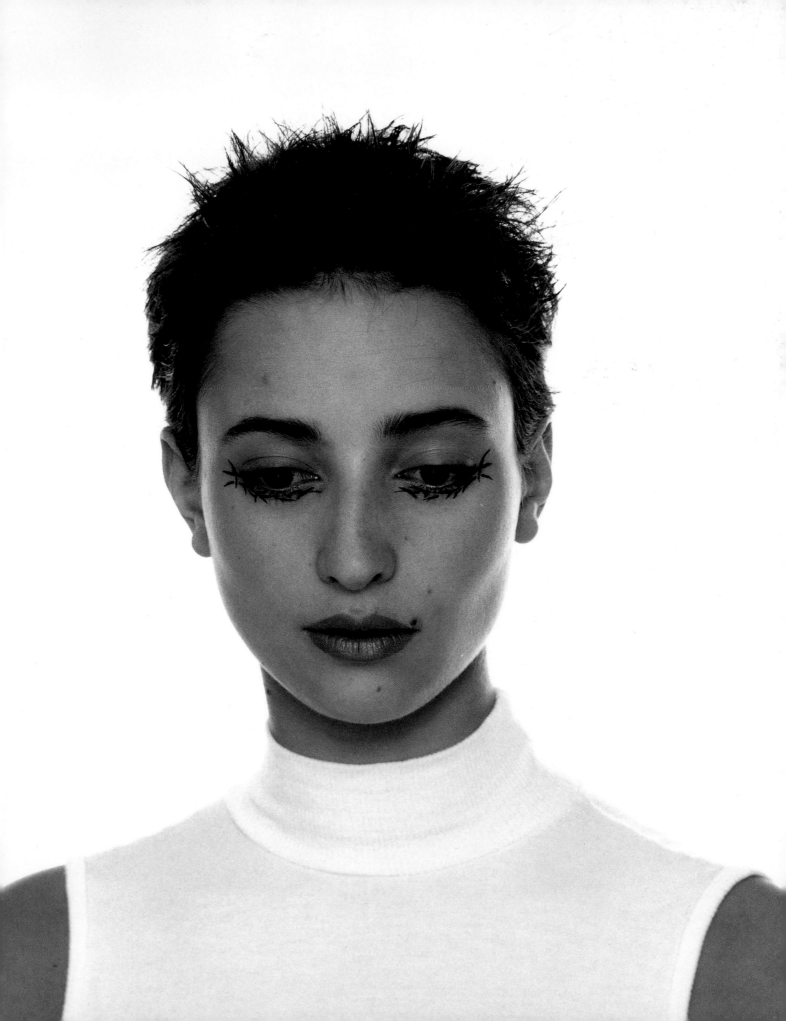

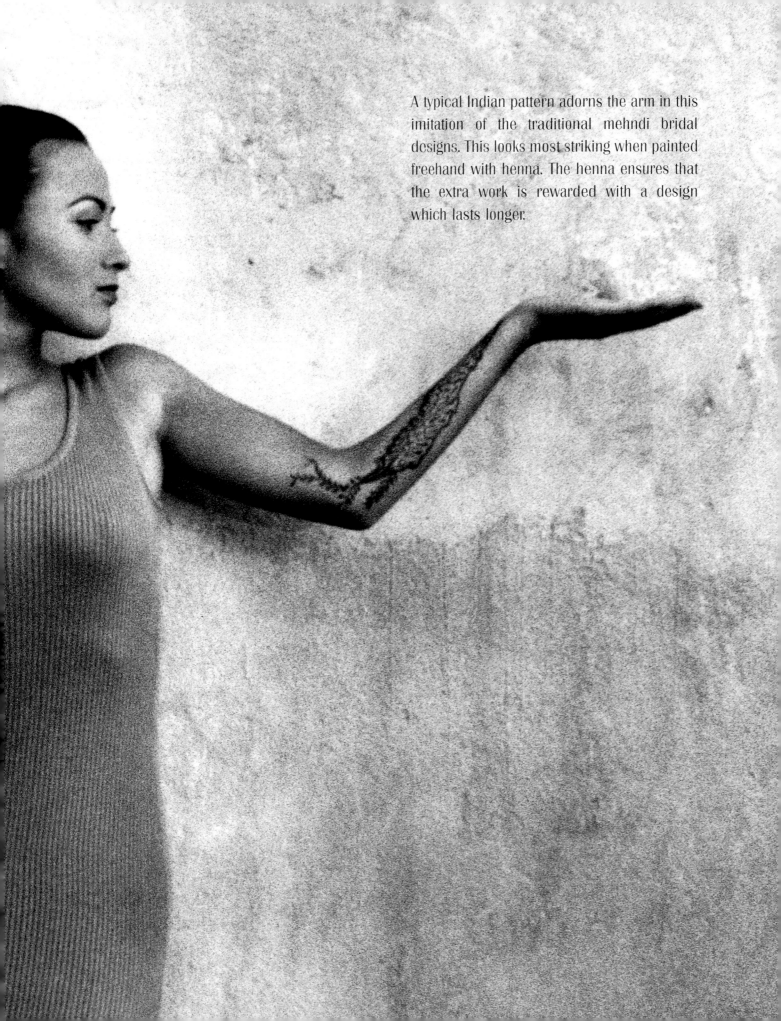

A typical Indian pattern adorns the arm in this imitation of the traditional mehndi bridal designs. This looks most striking when painted freehand with henna. The henna ensures that the extra work is rewarded with a design which lasts longer.

This flowing pattern should be allowed to run from the neck down to the shoulder. It is a good example of the kind of Celtic tattoo that is currently fashionable, and it suits both men and women. Of course, it is shown off to its best advantage by a short haircut, or hair that has been pinned up. It is easiest to produce with a tattoo pencil, but also works particularly well as a genuine henna painting.

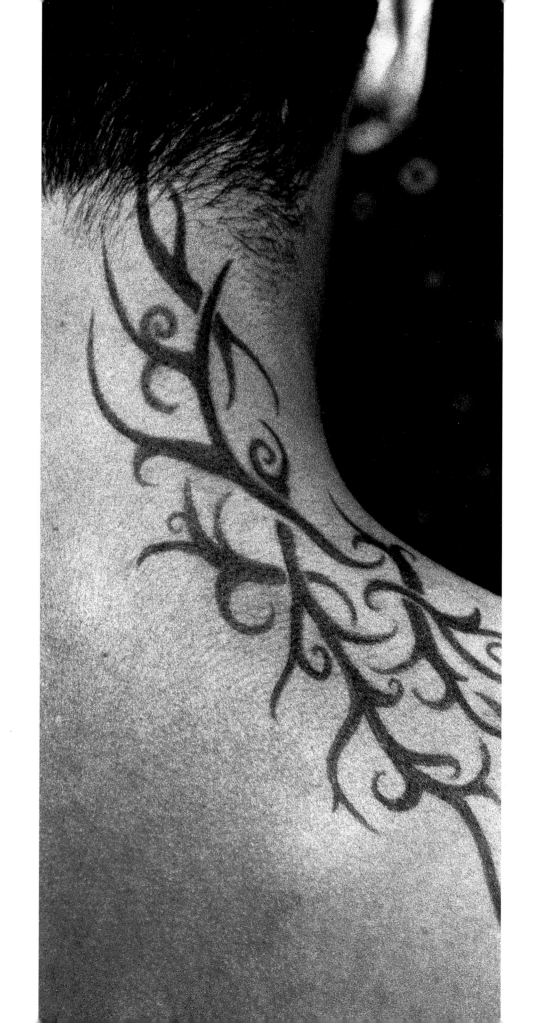

A stylish variation for sarongs, wrap-around skirts or skirts with a split. This looks most effective alongside plain material. If you would like to match the colour of your clothing, paint the design using a tattoo pencil or face paints. With henna, the effect is softer in tone, but no less impressive.

There are no boundaries for your imagination. A much-reduced classical or Celtic design or a band of intricate Indian patterns can be just as effective in this position.

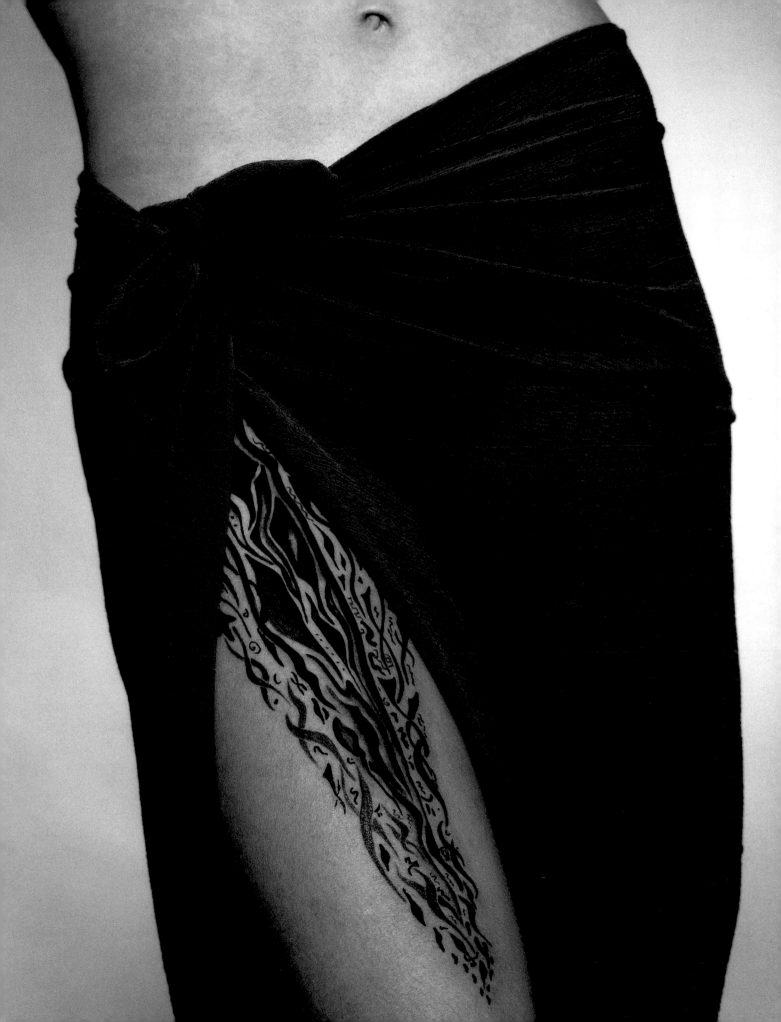

Angel wings are our recommendation for the backless evening dress.

For a complicated design like this, which has to be symmetrical, you need to use a stencil (see page 80). In addition, you will of course need help drawing the design, as well as time and patience. Waiting for the pattern to dry can be difficult, so it is best to paint these wings with a tattoo pencil.

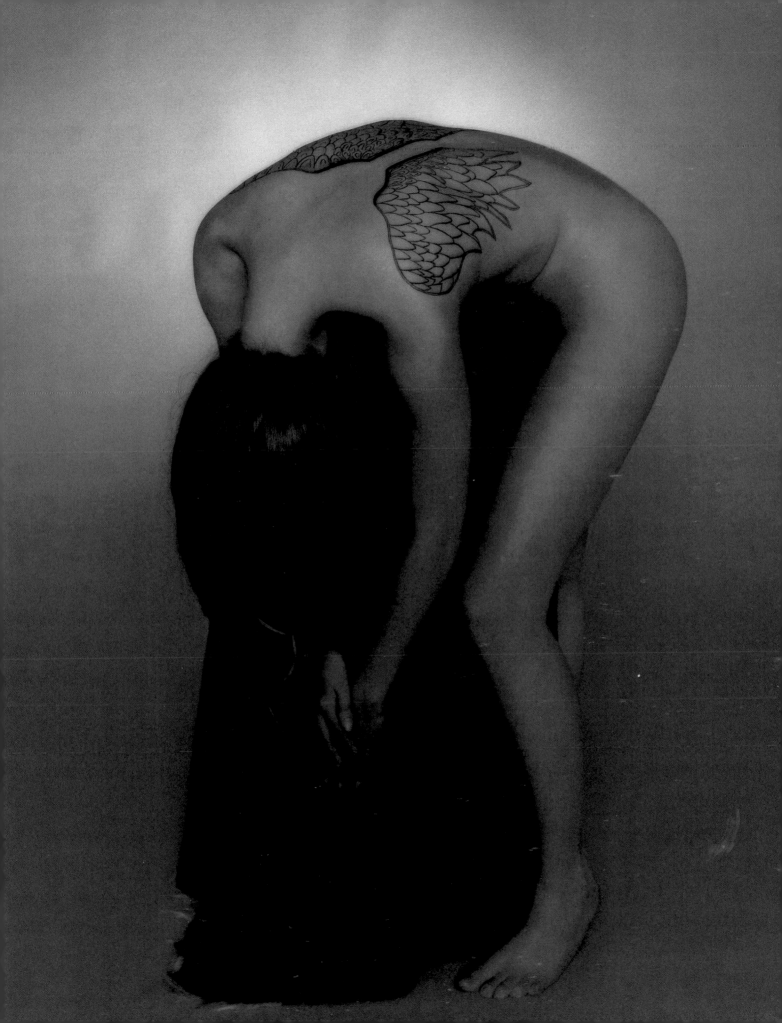

A traditional mehndi design. The paste remains on the skin, slightly dried out, giving an intense colour and a three-dimensional effect. We created this pattern using green henna paste from Pakistan, which has a particularly strong colour. However, you can use any type of ready-made henna paste or mix your own colour. This kind of mehndi pattern looks particularly attractive in the summer with sandals. It is worth investing some time and creativity in this, as the henna will last about three weeks.

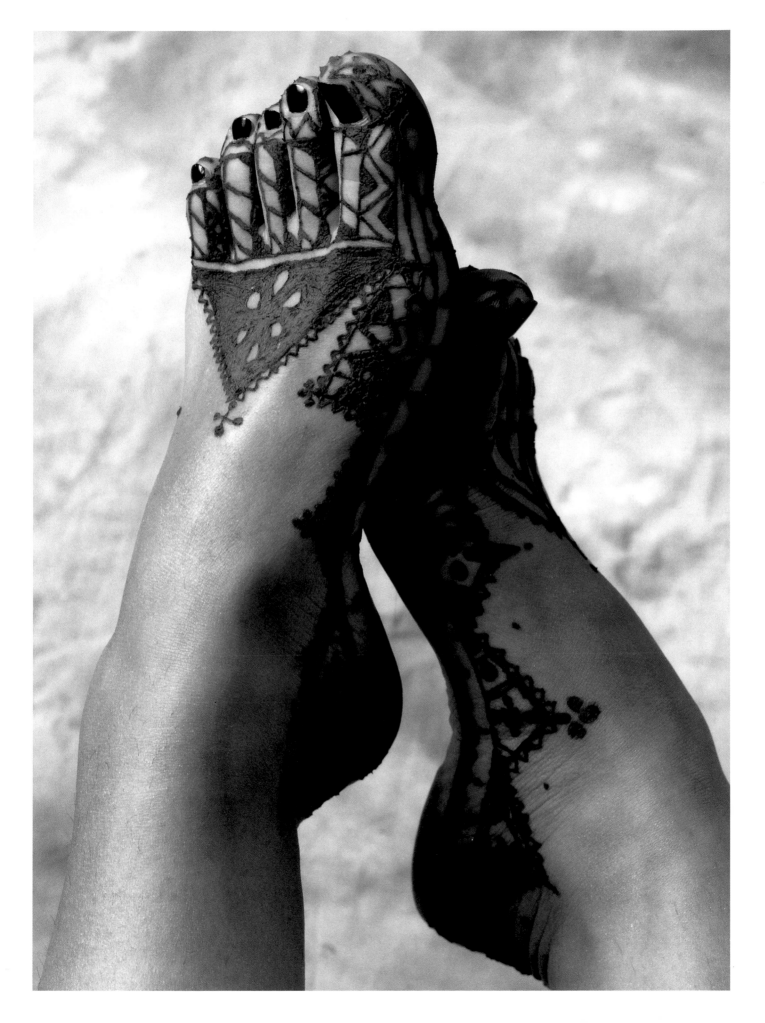

This form of hand adornment was famously sported by Madonna, among others. Delicate classical or Celtic designs work well on the hands. Apply these patterns with henna paste or home-made henna to make them last as long as possible. Use face paints if you wish to achieve a dark colour like ours, but the pattern will then only last for a day.

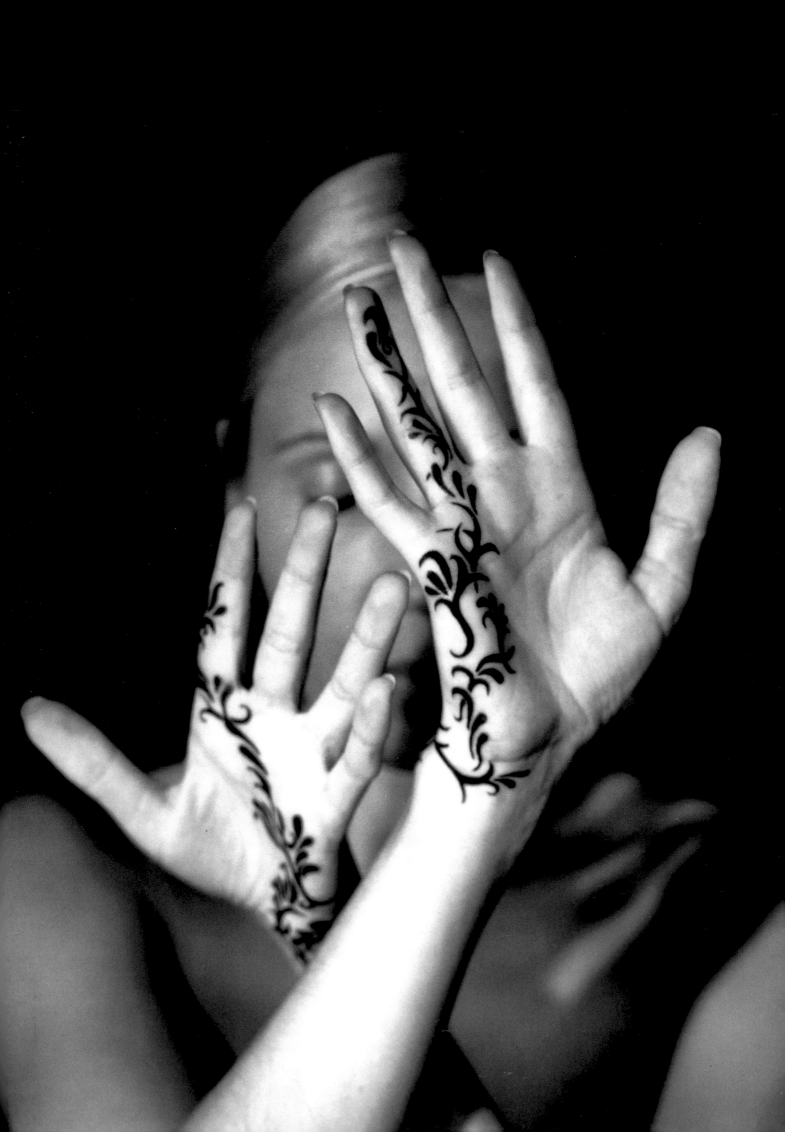

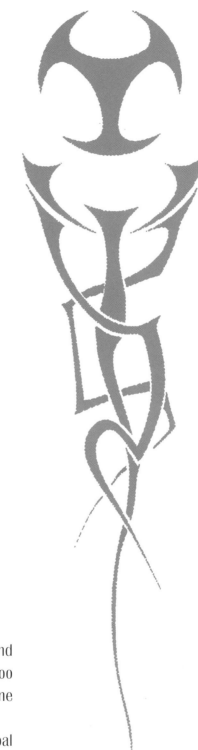

Bands around the upper arm look stylish and eye-catching. This design, created with tattoo ink, looks deceptively similar to a genuine tattoo.

An alternative for the upper arm is a tribal design like the one above. It runs down the upper arm instead of around it.

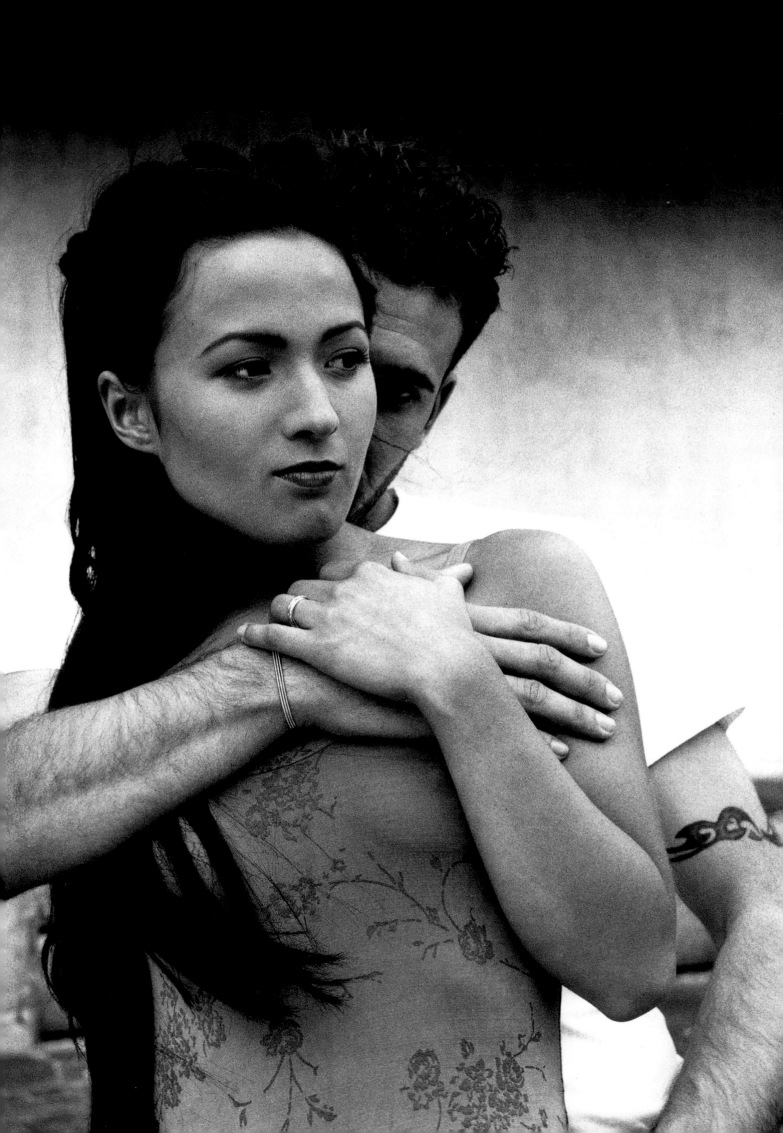

Create a stencil from this pattern (see page 80) which fits around your arm exactly so that the 'chain' closes nicely. You can use henna as well as face paints. Perhaps you could try it first with the face paints and then, if it works well, go over it with henna paste.

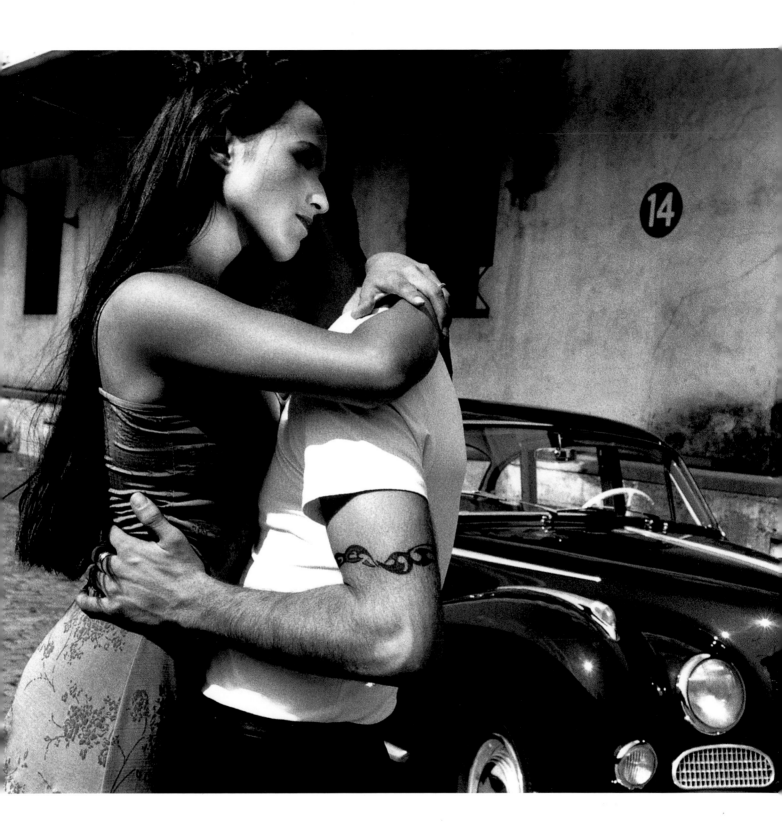

Another traditional mehndi design which should only be painted with genuine henna. This will draw attention to your ankles in the summer and can last for up to three or four weeks if you follow the correct aftercare procedures. It looks great with short dresses.

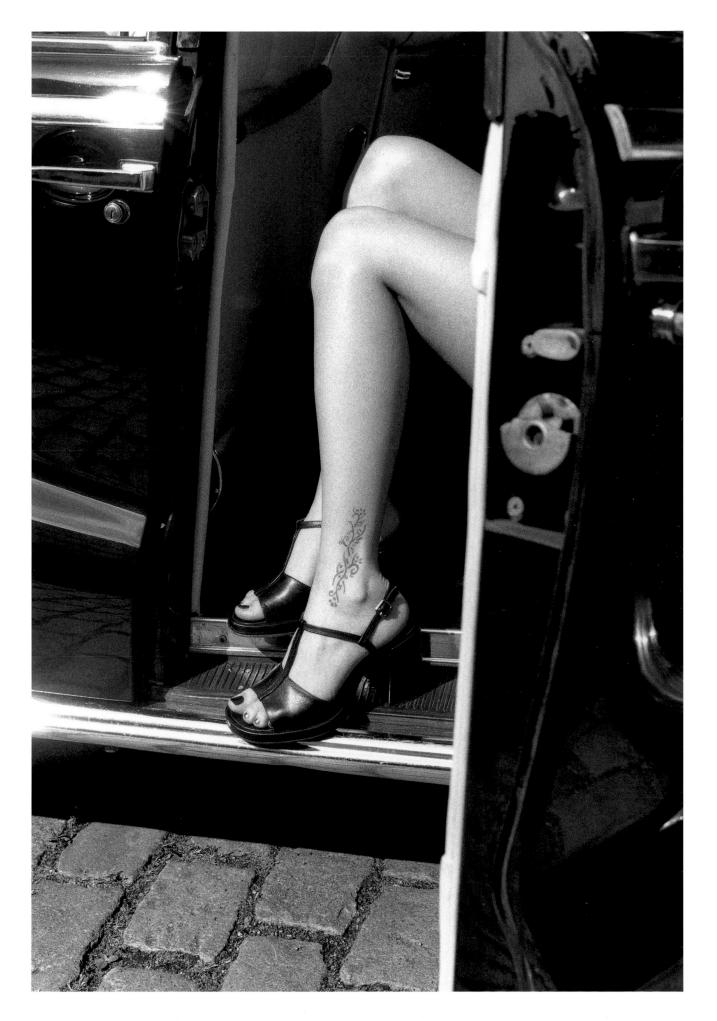

Show off your forehead – symbols from other cultures are particularly effective on the forehead. Work with henna or, for evening make-up, with gold or silver powder. It is especially fashionable to use heavily symbolic signs like the Indian caste signs or religious motifs (see page 62).

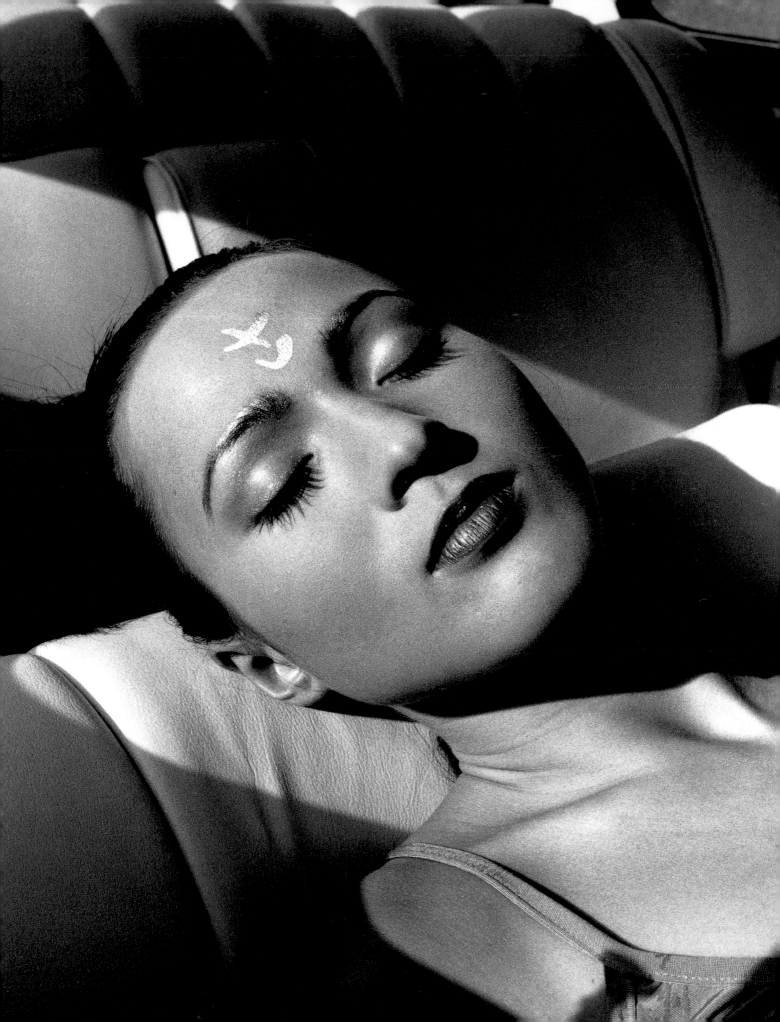

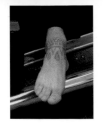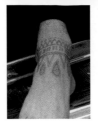

A mehndi design for men: a stylish application of Indian tradition for the Western fashion scene. This pattern must be applied using henna. Follow the instructions for aftercare (see page 77) to ensure that your design lasts. To see the development of this mehndi design, turn to page 75.

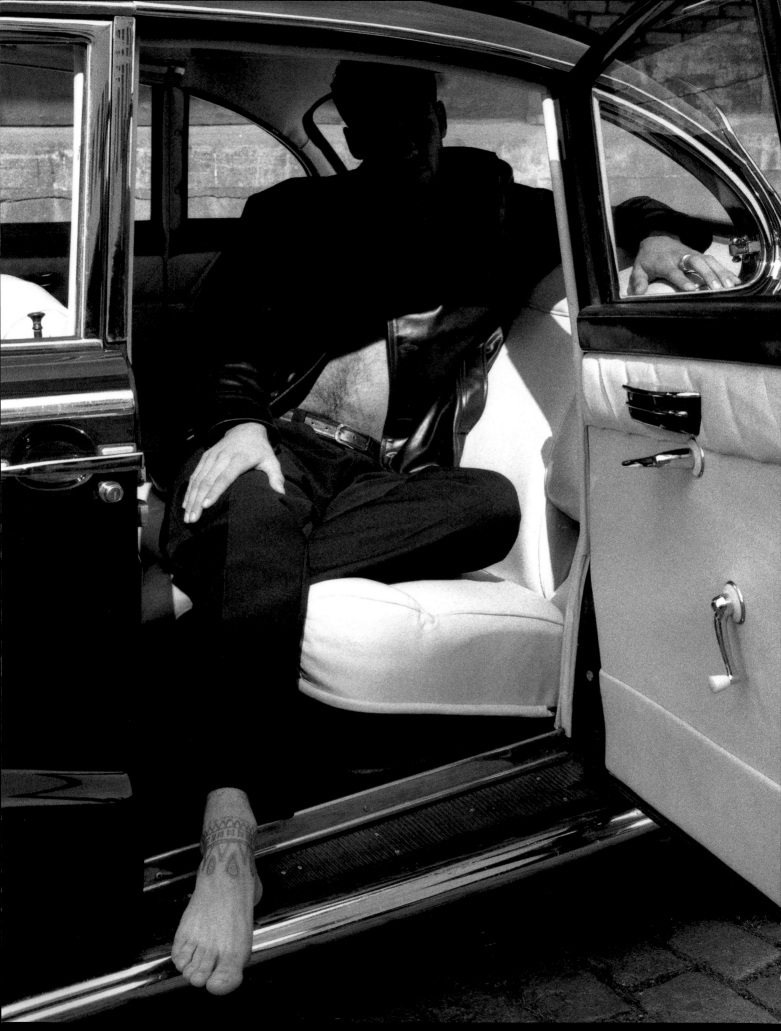

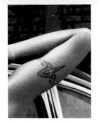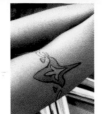

On both men and women, the upper arm is a particularly suitable place for a tattoo. Whether you prefer Celtic, modern or mehndi designs, there are no boundaries for your creativity. Play with the decorative motifs, colours and materials available to you. You will soon work out what you like and what suits you best.

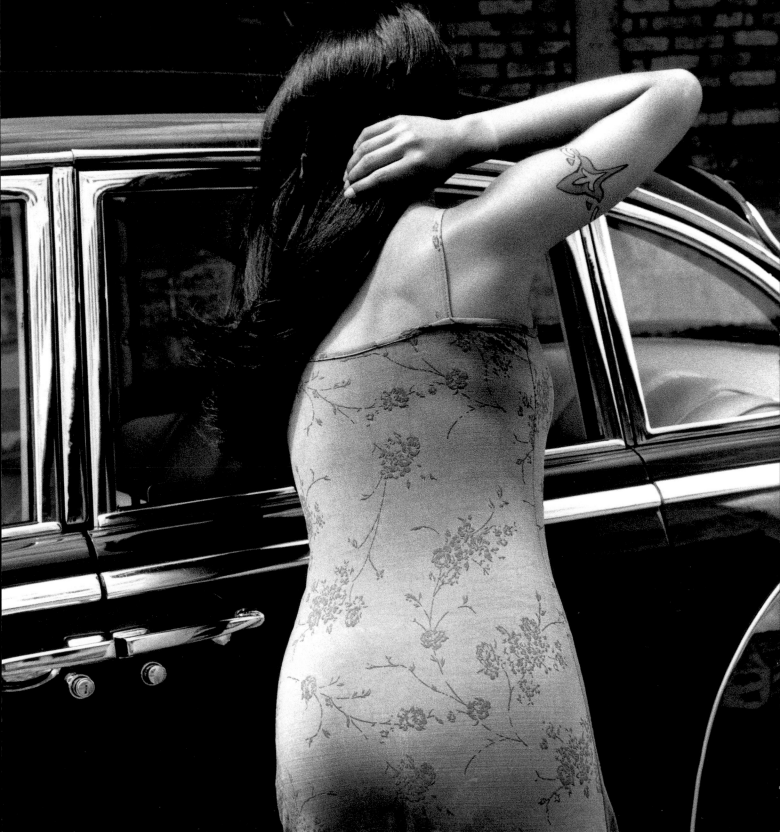

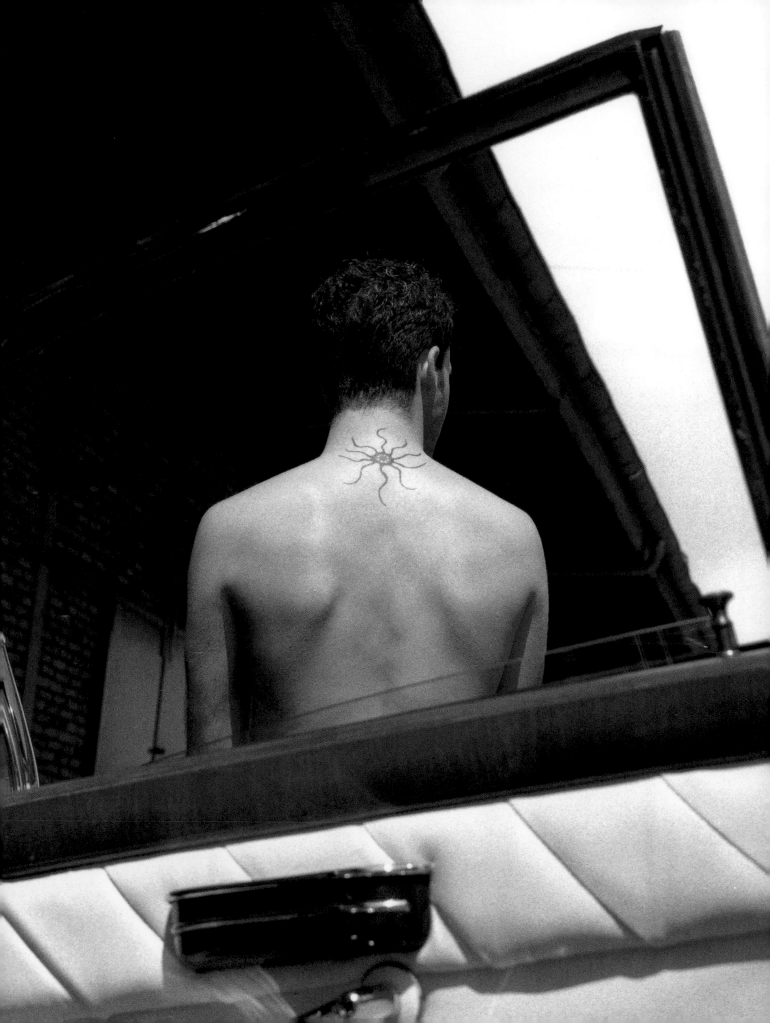

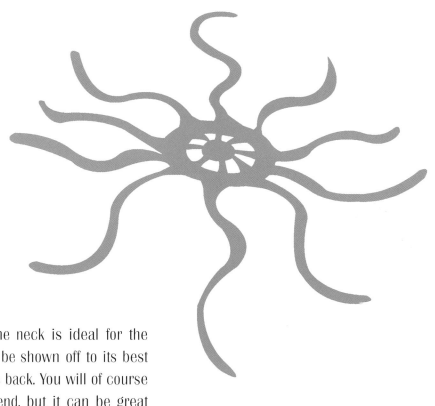

This decoration on the neck is ideal for the summer, when it can be shown off to its best advantage with a bare back. You will of course need help from a friend, but it can be great fun to paint henna tattoos on each other.

A Moorish pattern in an unusual position. It is a great substitute for jewellery, but more than a little courage and skill are required. If it is for a special occasion, let a make-up artist paint the design for you. Otherwise, it is best to use face paints. Choose a colour that matches your clothes.

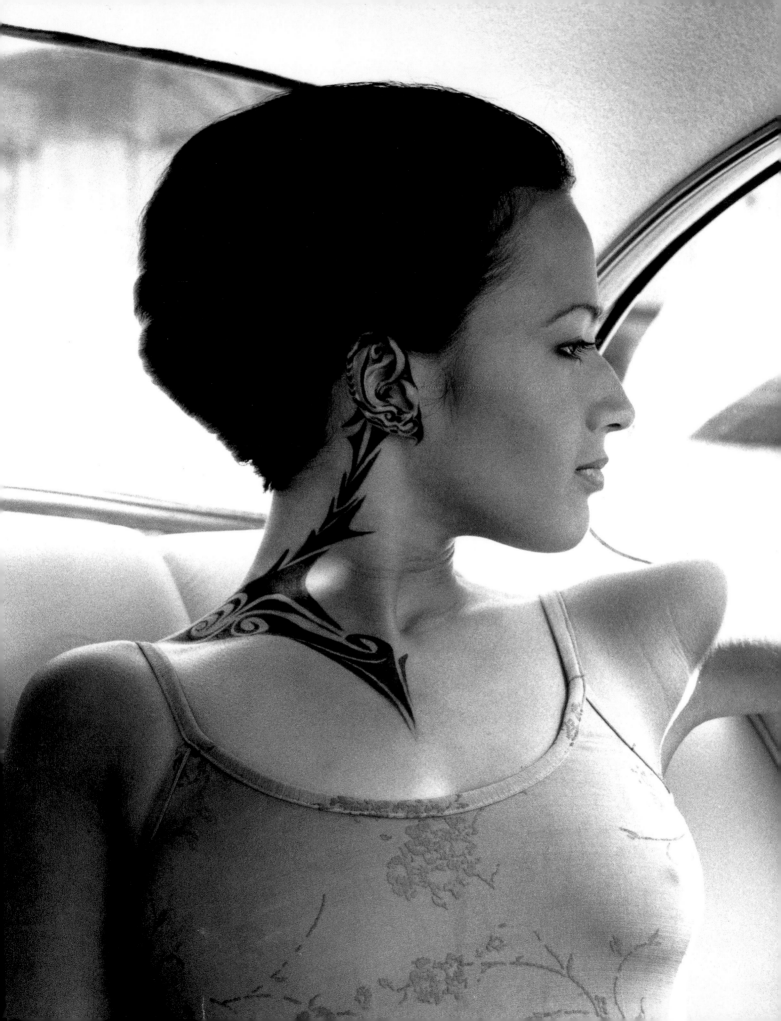

HISTORICAL
BACKGROUND
AND TECHNIQUES

TRADITIONAL BODY PAINTING WITH HENNA

The art of decorating the body with henna has come to us from various Eastern and African cultures. India and Tunisia, for example, have used henna for thousands of years as a beauty treatment and form of make-up, as well as for ritual painting and decoration of the body. These forms of body art are usually based on religious or traditional rites. The colours vary from a range of red tones to a dark, almost black colour. The natural henna gives the red or orange colours; the darker colour is created by adding substances such as soot. (Be careful when using these additional ingredients at home – they can sometimes cause an allergic reaction.) The darkest colours are most common in Tunisia. The most typical example of traditional henna painting is found in India, where the bride is lavishly adorned with patterns on the arms, hands and feet.

MEHNDI, THE INDIAN BRIDAL DECORATION

Before her wedding, an Indian bride Is decorated with intricate henna patterns called mehndi. In particular, the feet, hands and arms up to the elbows are painted. To achieve this, all the female relatives and friends of the bride are invited to a celebration a few days before the wedding. The mothers and grandmothers sing what are known as mehndi songs, in which the bride's future is described in a humorous way. At least the first dot of the henna painting must be made by the future mother-in-law. These rituals are supposed to bring good fortune to the marriage. In some regions, it is traditional to work into the pattern the initials of the groom, which the new husband then has to find on their wedding night.

The mehndi ceremony can be exhausting for the bride. She has to sit still for hours at a time, and the painting sometimes lasts for up to three days. At this time, the young woman is heavily dependent on other people. She has to be carried around once her feet have been decorated, and even the movement of her hands is greatly restricted.

These carefully applied designs remain visible for up to six months. The most common patterns are crosses, waves, leaves and petals, such as stylized lotus petals, for example.

SYMBOLS: THE HIDDEN MEANINGS BEHIND MOTIFS

In India, tattooing is an ancient and meaningful tradition. Here in the West, we often assume these beautiful patterns are purely decorative. However, even today, when fewer and fewer people follow these traditions, and when the social regulations that govern who may wear which symbol are loosening their hold, it is still possible to assign meanings to most symbols. Naturally, in India, everyone understands them. The designs on an individual's body are personal to them, but they can also represent group solidarity, as it is possible to recognize on another symbols common to your shared culture.

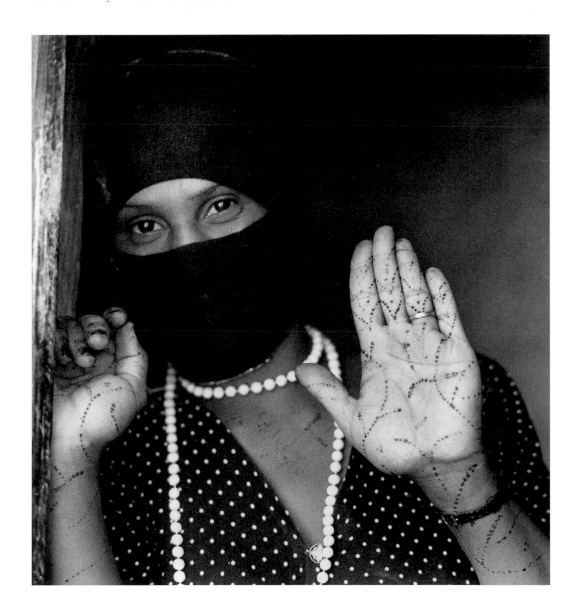

A quick look at the 'language' of Indian tattoos provides us with the following interpretations:

RELIGIOUS SIGNS

Om
Sign for God

Damru
Musical instrument

Panihari
Women carrying water vessels on
their heads

Phul
Flower

Bajoth
Plinth

Badam
Almond

Singasana
Throne

Derdi
Small shrine

Orani
A wooden instrument for sewing

Panchkan
Five seeds
Symbol for domestic harmony;
a woman among four brothers who live without quarrelling.

SYMBOLS

Protection from the evil eye
Also the symbol for Venus (female)
and the moon (male) and so of lovers

Symbol for marital bliss
The man as the moon with a dot
underneath representing his partner

Protection from all evil
Line between the eyebrows

The nine planets are thought to have power over
the fate of the dead. The ring of precious stones is
supposed to protect against their sometimes
evil influence.

(Eight-sided) lotus: Seat of the god of wellbeing, called Lakshmi. Can be represented in many different
ways. The eight petals of the flower are also compared to the eight points of the compass, or sometimes
the symbol is said to take the form of two squares on top of each other, one representing heaven and
one the earth.

Triangles form the mystical symbol for female strength, yoni. The sign of the fish, drawn from triangles, is not
only a symbol for yoni but also for fertility and good fortune.

The peacock is a symbol of
sovereignty.

Scorpions, snakes, bees and
spiders are symbols used for
protection, particularly when
they are tattooed in a sensitive
position.

The parrot is a bird of love,
symbolizing charm.

Modern Henna Tattoos

An ancient tradition has now become a fashion trend. In Hollywood, stars like Madonna and Demi Moore were some of the first celebrities to appear in public adorned with henna tattoos. Top fashion designers then took up the idea for their new collections, so that henna designs have been admired on catwalks around the world alongside the new fashions.

In the first part of this book, we presented our designs for you to copy or use as inspiration to create your own patterns. There are many different techniques for applying henna – more information is given from page 67 onwards.

Henna: Origins and Properties

Henna is extracted from the petals of a plant cultivated in Tunisia, Morocco, India and Egypt. The leaves are harvested, dried and then crushed to a powder. The factors that decide quality and colour are time of harvesting, climate and area of cultivation. If the leaves are picked in the spring, the henna is colourless and can only be used in preparations for the hair; harvesting in the autumn produces a red powder. The colour intensity depends on the climate and region. In the shops, it is common to find henna powder mixed with herbs or natural colouring agents, as the plant contains high levels of tanning agents which can react with the skin's pigment or penetrate the hair shaft.

The henna powder used in body painting must be as finely ground as possible. In addition, it should be completely free of pesticides, metals and other harmful ingredients like artificial colourings. Be careful of black henna – this often has soot added to it, which is not good for the skin.

The Colour Tones

Henna produces an orange-red to red-brown colour on the skin. In some cases, a dark-red or purple colour can be achieved. The tone is a very individual matter and depends on various factors, the most important of these being the method of application, the added ingredients, the time taken, the part of the body tattooed, the colour of the skin beforehand and the aftercare procedure followed. The coloration is usually darker on the feet and hands than on other parts of the body, as the flow of blood there is noticeably stronger.

To achieve a darker colour, cold strong coffee, black tea or red wine can be mixed into the henna powder. The ratio of lemon juice, which is always used (see page 67), should be about one part to five parts of tea or coffee. This mixture must be left to stand as long as possible (preferably overnight) and then boiled up again before the henna powder is added.

If you wish to be sure that the powder will not cause an allergic reaction, you should carry out an allergy test in advance.

A Simple Allergy Test

Mix up a little henna powder (see page 67) or take some of your chosen henna paste and apply it to the inside of the elbow, where the skin is particularly sensitive. Let the colour sink in for a short while and then remove the henna. The colour should no longer be visible. If you suffer no allergic reaction, then you can go ahead and apply your henna tattoo.

Do-it-Yourself Tattoos

Henna designs are often described as henna tattoos. This is not exactly correct – a tattoo is created by sticking a needle into the skin. Using our method, the skin remains completely unharmed; we even care for the skin with conditioning treatments. The second main difference is that henna paintings disappear after a short time – a good reason not to worry about giving it a try.

Originating in America, the henna fashion has swept across Europe and is becoming more and more popular. The Indian mehndi patterns are particularly favoured, but Celtic motifs and African patterns are also widely used. They can all be worn to contrast with or complement your clothes, jewellery or make-up. Whichever design you choose, you will create an individual and eye-catching look.

All of the designs on pages 10–57 can be copied, adapted or just used for inspiration. On the following pages we present some of the most important henna-paste recipes and techniques.

HENNA PAINTING STEP BY STEP

The following range of henna-painting methods can be varied according to the extravagance of the design and how long you want it to stay on your skin. There are many ways to adorn your skin for just a day or an evening, to match a particular piece of clothing or for a special occasion. Or you can henna your skin in summer with attractive designs that last for several weeks. Take inspiration from our patterns and try some out.

For a genuine mehndi look you should use the traditional method and work with real henna powder. This gives the most striking results and lasts longest. However, if all the preparation is too costly or time-consuming for you, you can fall back on ready-made henna paste. Both kinds of henna can be applied freehand or using a stencil. If you want the design to last only two or three days, you can use a special tattoo pencil. As well as being relatively easy to use, they are available in a number of different colours. In the case of a pattern which is only intended to last for one day or an evening, we recommend you use an eyeliner pen, which can also be used for everyday make-up. If you want to create a deceptively genuine-looking tattoo, it is best to use tattoo ink, which is also available in a range of colours.

HENNA POWDER

There are various formulas for mixing and applying henna powder. The traditional method follows, in step-by-step detail.

You will need:
- glass, porcelain or plastic bowl
- teaspoon
- about 30 g (1 oz) henna powder, finely sifted
- nylon stocking
- juice of a lemon (or lime)
- cold strong coffee and black tea
- mehndi oil
- cotton wool
- gauze bandages
- sugar

67

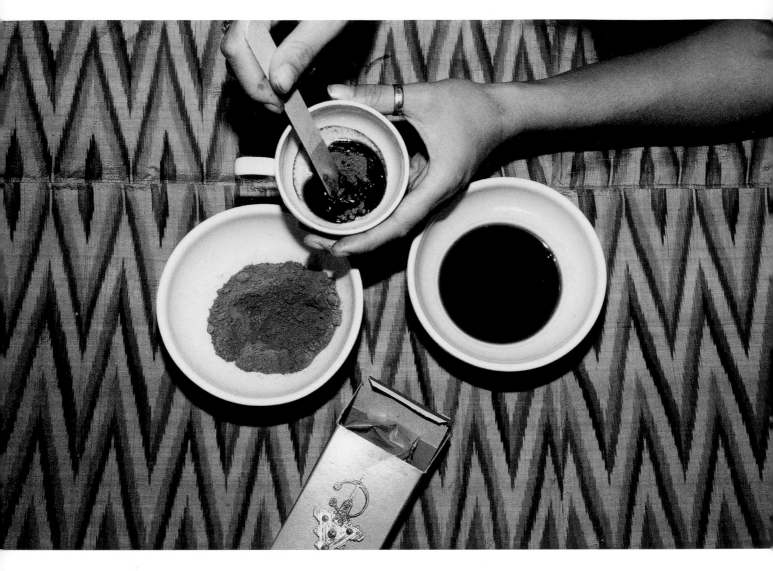

Making the paste mixture is easy – follow the instructions below:

- Sieve the henna powder through the nylon stocking so that it is very fine, with no lumps to block your applicator.
- Mix the coffee, tea and lemon juice – one part lemon juice to five parts tea and coffee. This mixture must be allowed to stand for several hours, preferably overnight.
- Boil up the liquid and stir in the henna powder – one part henna, one-and-a-half parts liquid.
- Add a few drops of mehndi oil at the end and stir until no more lumps remain. The paste must stand for at least 4 to 5 hours before use.

Tip:
If you want to achieve a particularly intense colour, use lime juice instead of lemon and add the rind to the mixture before it is left to stand overnight.

HENNA PASTE

Those who find the procedure opposite too time-consuming can always use a ready-made henna paste, now widely available (see Useful Addresses for stockists). It comes in a tube with a nozzle which you can use to draw with. You can, of course, transfer the paste into a cone or a piping tool (stockists are listed under Useful Addresses).

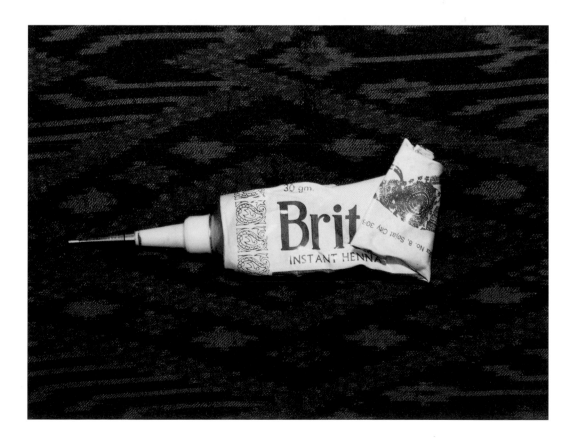

DRAWING YOUR PATTERN

The henna paste can be applied in different ways, depending on your chosen pattern. If you are good at drawing, work freehand with a fine paintbrush, wooden stick or piping tool, as we have to create the design on this hand.

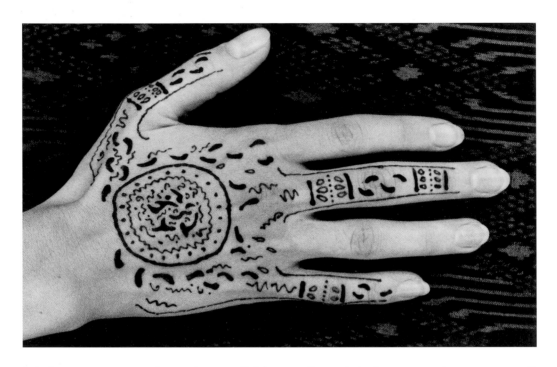

It is best to use a ready-made stencil for complicated designs, or make one yourself (see page 80).

THE FREEHAND METHOD

You will need:
- henna paste
- mehndi oil
- surgical spirit
- mixture of icing sugar and lemon juice, fairly runny
- cotton wool or a small sponge
- gauze bandage
- small stick or fine paintbrush
- piping tool

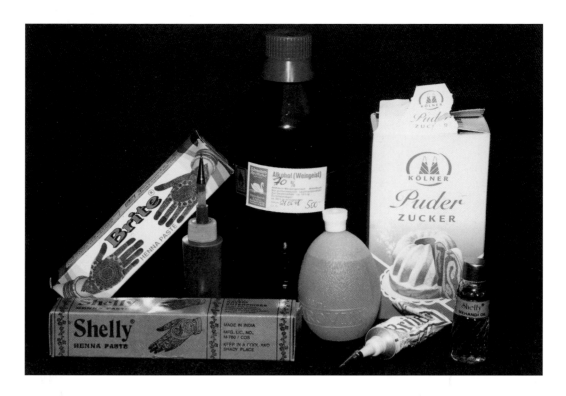

Proceed as follows:

- Decide on a pattern.
- Wash the chosen area of skin thoroughly.
- Mix a little mehndi oil with some sugar and use this to exfoliate the skin – the exfoliation clears the area of dead skin cells.

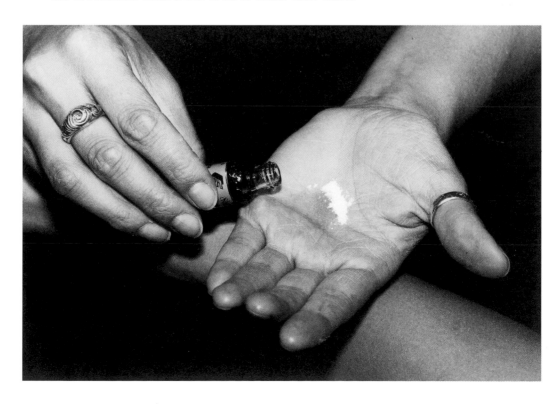

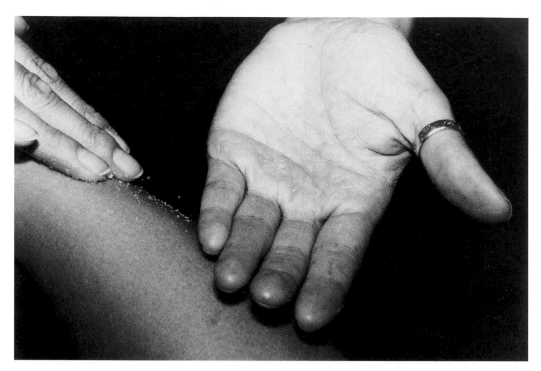

● Clean the skin with surgical spirit and rub in some more mehndi oil. This conditions the skin and increases the staying power of the colour.

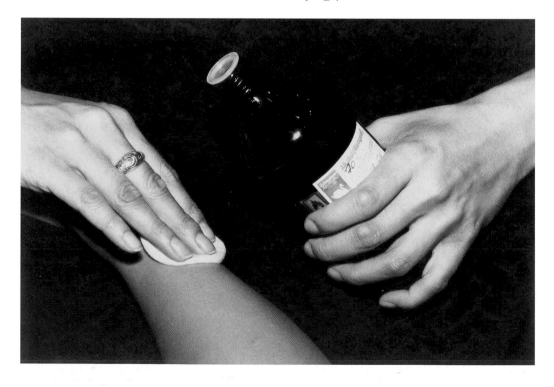

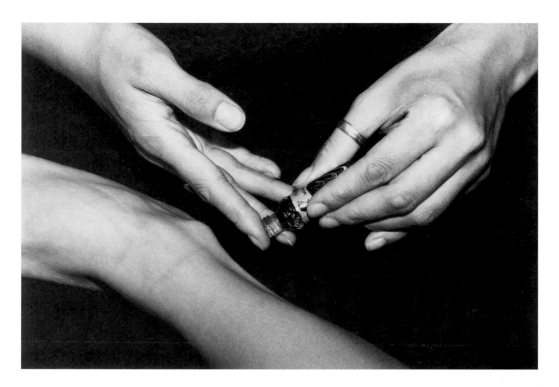

- Transfer some of the henna paste into a piping tool, or use the tube's nozzle. The thick lines can be drawn with a small stick or paintbrush, the finer ones with the piping tool. Have a pin or some nylon thread to hand to clear the nozzle if it gets clogged up.
- Apply the paste on to the skin in a layer about 0.75 cm (¼ in) thick.

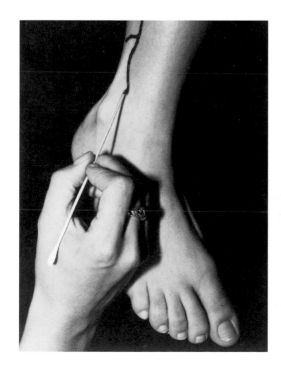

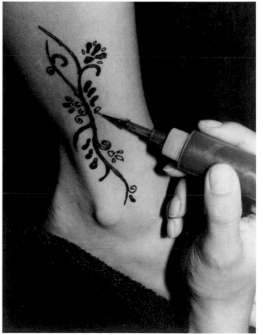

- Wipe away any mistakes immediately with a piece of cotton wool soaked in surgical spirit.
- Every so often, coat the layer of paste with the lemon juice and icing sugar mixture, using cotton wool, a sponge or a paintbrush. The longer the paste remains moist, the more it will be absorbed into the skin and so the more intense the colour.

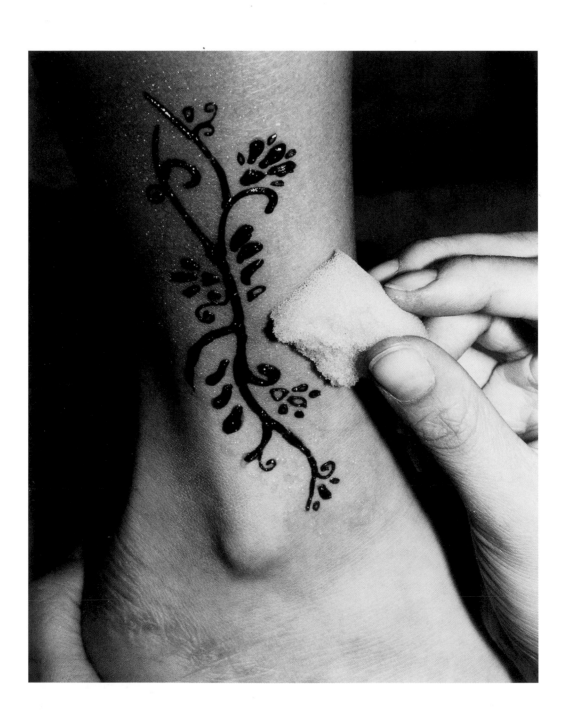

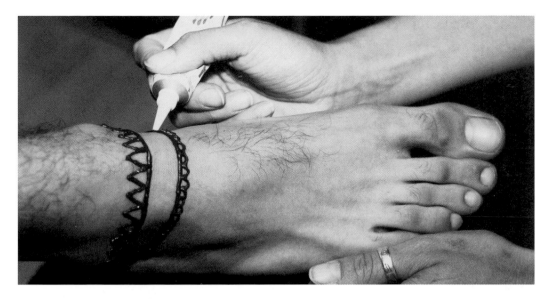

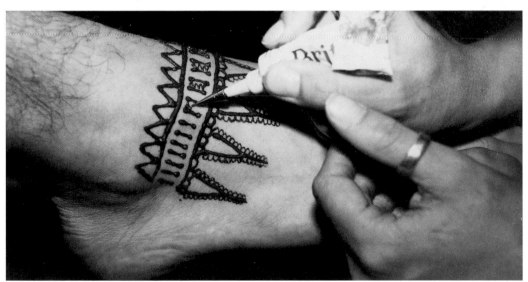

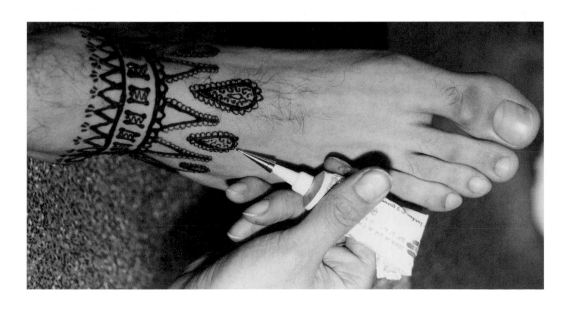

The typical mehndi pattern on page 75 was drawn freehand using ready-made paste. Start off with the lines which form the shape before adding the finer detail. For an intricate design such as this, it is a good idea to find a pattern to copy or to draw your design on paper first so that you can work out how to divide up the area you are decorating. Be careful not to smudge your pattern while working on it.

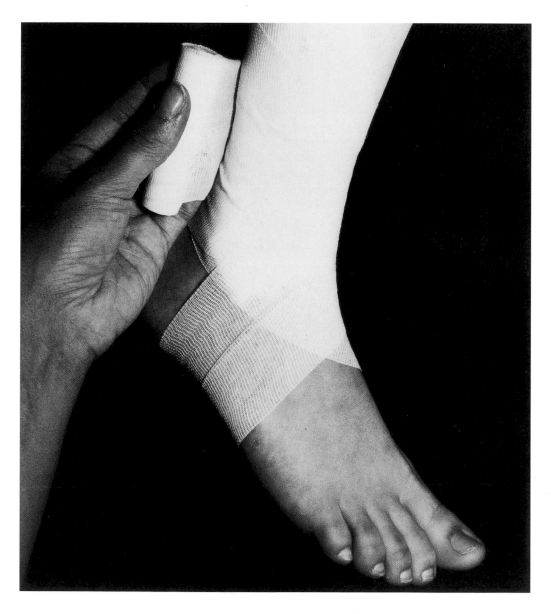

● When the pattern is finished, wrap the decorated area in a gauze bandage or secure a cotton pad over it with plasters. This will protect the design.

Aftercare

To achieve the best results, the henna paste should remain on the skin for 12 to 15 hours (overnight is best). Undo the bandage and wait for 10 minutes. Now you can remove the dried paste with a spoon or a fingernail. After another 30 minutes, carefully dab the decorated skin with a mixture of olive oil, sugar and lemon juice. Do not allow any water to come into contact with this area for another 4 hours.

If you follow these directions, the pattern will last for three to four weeks. If the henna is washed with water or the waiting time is not adhered to, the tattoo will fade within hours.

The tattoo will last for longer if you
- avoid getting shampoo or soap on the skin
- do not use a sunbed or sit in strong sun
- prevent alcohol and salt from coming into contact with the skin
- do not use exfoliating products

Working with Stencils

If you wish to create a complicated pattern, or you don't trust your drawing abilities, use a stencil. These are readily available in the shops. You can also make your own stencils.

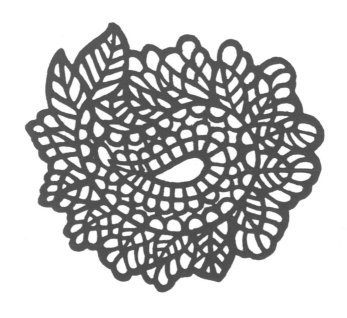

Using stencils is very easy.

You will need:
- stencil
- spoon or wooden spatula
- cotton wool
- eucalyptus oil

● Prepare the skin: use sugar and mehndi oil to exfoliate, then clean the skin thoroughly with surgical spirit.
● Attach the stencil to the skin, taking care to ensure it is properly stuck down in all places.

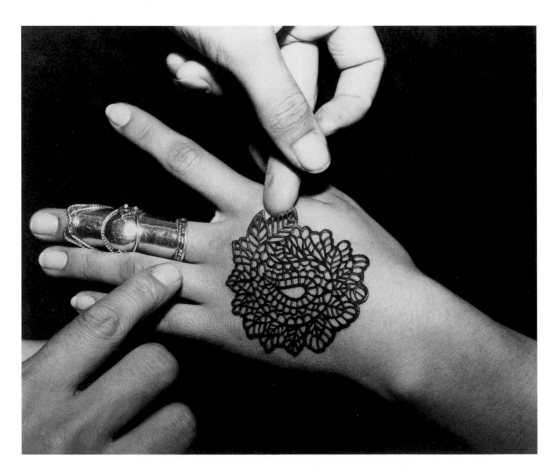

● Spread a layer of henna paste over the stencil, about 0.5 cm (¼ in) thick. Ensure that the whole stencil is covered. It is best to spread on the paste with a spoon or a wooden spatula.

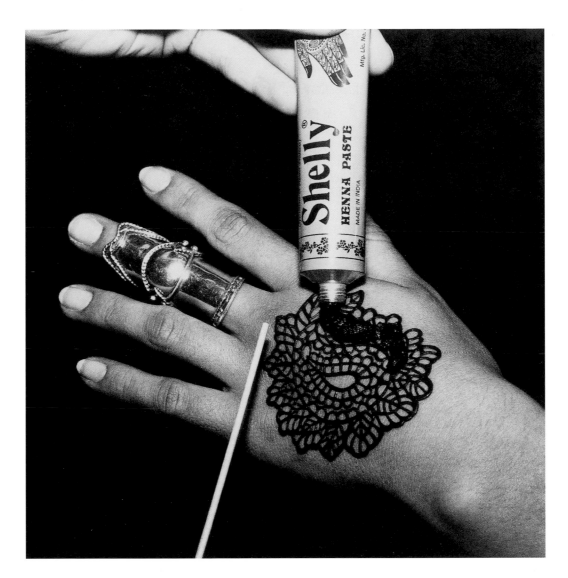

- Work very carefully around the edges and wash away any paste which slips over.
- Leave for about 45 minutes to let the henna soak in. The paste must be allowed to dry completely.
- Next, apply a few drops of eucalyptus oil to the paste and dab it with cotton wool.
- Leave for another 45 minutes.
- Remove the stencil carefully and clean off the remaining henna paste with a cloth or cotton wool.
- Let the skin rest for 10 minutes.
- Put a few drops of eucalyptus oil on some cotton wool and dab the tattoo all over. Your henna painting is finished.

Quick Tips

If you would like to wear a stencilled pattern for just one day or an evening, you can use a few tricks to make it easier:

- Clean the skin with toner.
- Make sure the stencil is properly stuck down all over.
- Brush the exposed areas with a generous dusting of waterproof eyeshadow using a soft blusher brush.
- Carefully clean the edges with cotton-wool buds soaked in toner.
- Remove the stencil.
- Fix the pattern with fixing spray. (Be careful: Avoid the eyes and hold the can 30 cm (12 in) away from the skin.)
- You can wipe off this pattern with make-up remover.

Making Your Own Stencils

If you don't want to use any of the stencils available in the shops, it is relatively easy to make your own. Find a pattern, or design one yourself, and copy it on to self-adhesive foil with a waterproof felt-tip pen. Cut out the pattern carefully using a sharp scalpel.

Instead of using a stencil, you can also apply the pattern of your choice to the skin like a transfer. Draw your chosen motif on carbon paper with a piece of blank paper underneath so that the pattern goes through. Lay the carbon paper against the skin and dab the back with a cotton-wool ball soaked in surgical spirit. You can do the same thing with a pattern drawn in pen on blank paper. This transfers a clear outline on to the skin which you can then go over or fill in with colour.

THE EYELINER PEN ALTERNATIVE

If you are in a hurry, or want to wear a design for just an evening or a day, eyeliner pens are a good alternative. They are easy to use and come in many colours. It is important that the tips are formed so that the ink doesn't come out too quickly, otherwise the colours run into the lines in the skin.

One great advantage of these pens is that they can also be used for everyday eye make-up, making them a good investment. The colour is touchproof, so you don't have to worry about smudging the pattern.

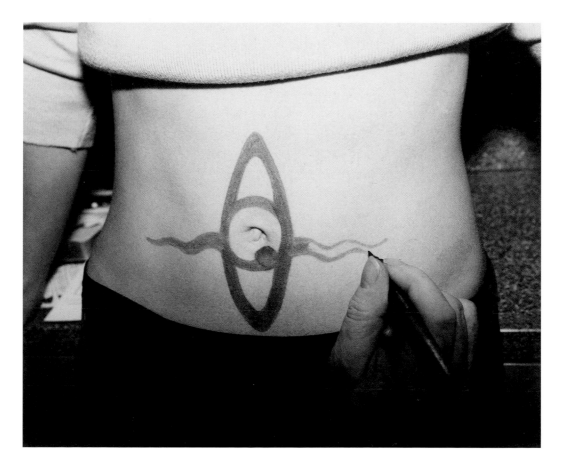

When working with eyeliner pens:

- Clean the skin with toner.
- Before using the pen, hold it with the tip upwards to prevent too much colour coming out at once.
- Set the pattern with a fixing spray.
- To remove the pattern, use cleanser or make-up remover.

TATTOO PENCILS

Tattoo pencils are good for drawing small designs or motifs freehand. The smooth, crayon-like feel makes them easy to draw with. L'Oréal Body Art pencils are available in blue, red, green and black, and the colour will last for up to three days on the skin.

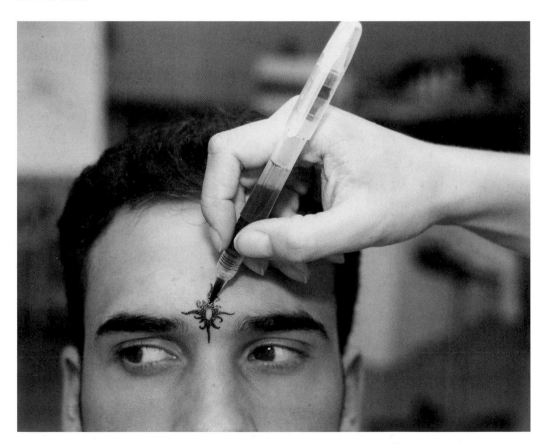

- Carefully clean the skin with surgical spirit before you start drawing – this will help the pattern to last for two to three days.
- If you want to wipe off the design sooner, use make-up remover.

TATTOO INK

Tattoo ink can also be obtained in bottles and painted on to the skin with a brush – this allows more precise work than is possible with a pencil. Kryolan tattoo ink is available in a range of ten colours. One advantage is that the colours are translucent, which means the texture of the skin shows through the design, giving it the appearance of a genuine tattoo. The ink is smudgeproof and lasts for two to three days on the skin.

As well as freehand designs, tattoo ink is also suitable for use with stencils. The tops on the bottles must always be closed properly, as the colours can dry out very quickly.

The instructions are very simple:
- Clean the skin with surgical spirit.
- Attach a stencil or transfer an outline to the skin using the methods described on page 80.
- Mark in the outline and fill in the spaces with your chosen colours. If you use several colours, ensure that the brush is thoroughly washed out and dried before you start painting with the next colour. Begin with the pale colours.

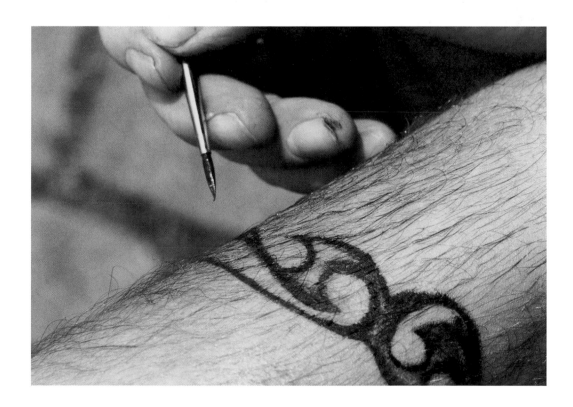

- Tattoo ink dries in less than 5 minutes but needs an hour to soak into the skin completely.
- These colours can be fixed with translucent face powder.
- Try to avoid getting water and soap on the decorated area so that the tattoo lasts longer.
- If you wish to remove the tattoo before it disappears by itself, use surgical spirit.

Tip:

If your pattern comes out well with tattoo ink and you would like to wear it for longer, you can go over the pattern with henna powder or paste. It will then appear in only the typical henna colours, of course.

FACE PAINTS

These are water-based body paints which can be applied with a make-up brush. They are particularly popular for children's face-painting but can also be used effectively for our purposes. Face paints come in many colours and are very easy to work with. These colours are often used for theatrical make-up, carnivals and fancy dress.

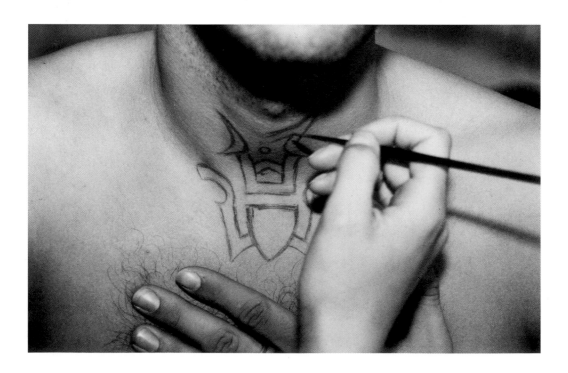

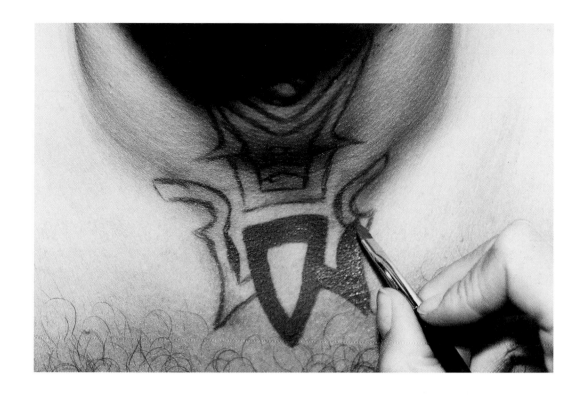

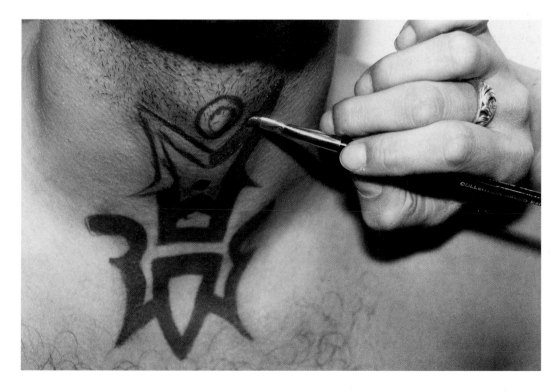

● Draw a fine outline of the chosen motif or transfer the shape on to the skin as described on page 80.
● Fill in the shape with a fine brush.

- Fix the completed design with a fixing spray. (Be careful: Avoid the eyes and hold the can 30 cm (12 in) away from the skin.)
- The painting can be wiped off with make-up remover or baby lotion.

Face paints last one day on the skin. They are often used for photo shoots and fashion shows, as they look genuine but can be removed quickly.

That's it for the different colours and methods. As you can see, there is a huge range of techniques and materials to choose from, depending on how much time and trouble you wish to take and the length of time you want the tattoo to remain on the skin. As all the colours disappear by themselves after a time, or can be easily removed, you don't need to worry about mistakes. Be imaginative – try out as many different things as possible.

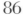

USEFUL ADDRESSES

The Body Shop
(Head Office)
Hawthorn Road
Wick
Littlehampton
West Sussex BN17 7LR
Tel: 01903 734500
*Stockists of henna kit containing
henna powder, herbs, 3 stencils,
piping tool, and a spatula.
Call for your nearest branch.*

Charles H. Fox
22 Tavistock Street
London WC2E 7PY
Tel: 020 7240 3111
*Stockist of Kryolan tattoo ink and
a wide range of permanent
make-up.*

L'Oréal
(Head Office)
30 Kensington Church Street
London W8 4HT
Tel: 020 7937 5454
*Suppliers of mehndi ink, stencils,
Body Art pencils, and mehndi kits
containing ink and a stencil
template. Call for your nearest
stockist.*

Selfridges
400 Oxford Street
London W1A 1AB
Tel: 020 7629 1234
*Stockist of henna powder, henna
paste, herbs, applicator, mehndi
oil, tattoo pens, stencils, and fixing
spray.*

Superdrug
(Head Office)
118 Beddington Lane
Croydon
Surrey CR0 4TB
Tel: 020 8684 7000
*Stockists of tattoo ink, stencils,
and tattoo pencils. Call for your
nearest branch.*

ABOUT THE AUTHOR

SABINE KÜHNE was born in 1957. She studied photography and has worked as a freelance photographer since 1981. Her work has been exhibited all over the world and featured in various international publications including *Die Zeit* magazine and the *Sunday Times*. She has been specially commissioned by companies such as Cartier, Sony and Audi. Ms Kühne is the artistic director of Die Maske school for make-up artists in Cologne.

ACKNOWLEDGEMENTS

My heartfelt thanks to all those involved in this project –

the models:
> Ralph Binkowski
> Melanie Brandt
> Frauke Kenfenheuer
> Lena Labusga
> Lisa Labusga
> Melanie Meyer
> Laura Schulz

the make-up artists:
> Bernd Bauer
> Wilhelmina French-Lyffyt
> Regina Gebel
> Martin Heim
> Sandra Jovic
> Nicola Pandel
> for Die Maske, Cologne

Helga Pisters for the step-by-step photographs

Benno Gebel for the kind loan of the BMW V8

Sebastian Kühne for the tribal designs

Picture Credits

Sabine Kühne: pages 11–59; page 72.
Helga Pisters: pages 63–71; pages 73–87.
Maybritt Fuchs: illustrations on pages 64–5.

The information on pages 63–5 is based upon:
Joshi, O., Jaipur 1992

HENNA PAINTING